FLOWERS

FLOWERS

J.E.H. MacDonald, Tom Thomson and the Group of Seven

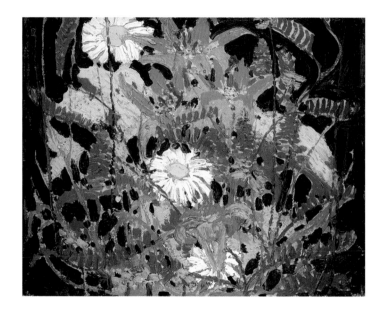

JOAN MURRAY

McArthur & Company

Toronto

First Canadian edition, McArthur & Company, 2002.

National Library of Canada Cataloguing in Publication
Murray, Joan
 Flowers : J.E.H. MacDonald, Tom Thomson and the Group of Seven / Joan
Murray.
ISBN 1-55278-326-X
 1. MacDonald, J. E. H. (James Edward Hervey), 1873-1932 – Criticism and
interpretation. 2. Thomson, Tom, 1877–1917 – Criticism and interpretation.
3. Group of Seven (Group of artists). 4. Flowers in art. I. Title.
ND245.5.G7M88 2002 704.9'434 C2002-903493-0

Front jacket photograph: *The Tangled Garden*, J.E.H. MacDonald, National Gallery of
 Canada, Ottawa
Back jacket photograph: *Orchids, Algonquin Park*, Tom Thomson, Carlo Catenazzi,
 Art Gallery of Ontario, Toronto
Title page photograph: *Marguerites, Wood Lilies and Vetch*, Tom Thomson,
 Art Gallery of Ontario, Toronto
"Autumn Sunflowers" is taken from *West by East and Other Poems*
 (Toronto: The Ryerson Press, 1933), page 29

Cover and interior design and typesetting: Counterpunch / Linda Gustafson
Printed and bound in Canada by Transcontinental Printing

McArthur & Company
322 King Street West, Suite 402
Toronto, Ontario, Canada, M5V 1J2

10 9 8 7 6 5 4 3 2 1

AUTUMN SUNFLOWERS

Here in the garden corner

What holy rite is done,

Between the breeze and branches

The sunflowers and the sun.

I sit beside the service

In which the flowers bend,

Their lowly rapture holds me

To listen to the end . . .

J.E.H. MacDonald

CONTENTS

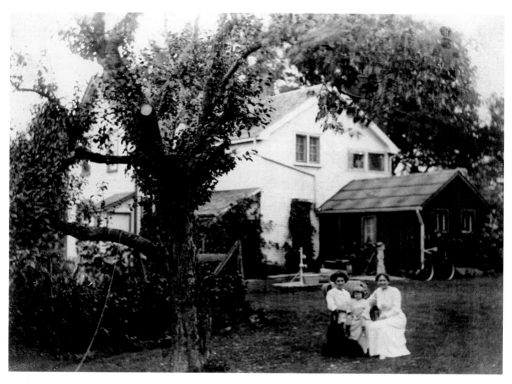

*Mrs. Arthur Lismer and her daughter, Marjorie, with Mrs. J.E.H. MacDonald in the
MacDonald garden in Thornhill. Thoreau MacDonald is in the background.*

THE ENERGY OF FLOWERS

J.E.H. MacDonald, Tom Thomson and the Group of Seven

Every wave of artists reinvents domestic garden imagery. J.E.H. MacDonald's landmark picture *The Tangled Garden*, created in Toronto in 1916, inspired a generation. The painting's lyrical intensity and direct connection to the physical environment of Canada made it an exceptional floral painting in this country.

MacDonald drew his inspiration from a scene that he knew intimately – the garden on the west side of a house in Thornhill, which was then a village north of Toronto where he had moved in 1912. Painted with dazzling bravura, *The Tangled Garden* faithfully depicts the scene at the same time as it reveals a bigger idea, one that has to do with the spirit of Canada itself as it is understood by most Canadians. With its giant sunflower nodding over an untidy garden, *The Tangled Garden* is painted with style and – so unexpected given the intimacy of its subject – grandeur.

The key to our understanding of the picture as a symbol of national consciousness lies in the vivid glimpse it offers of untamed and unruly nature. MacDonald approached the scene, with its dense undergrowth and distinctively shaped flowers, as though he were painting wilderness. He conveyed the impact of the view with a painterly touch that veered from graceful to bold, and he displayed a finely tuned sense of colour that deftly explored the reds, purples and pinks jostling among the greens and yellows of his subject.

With its striking colours, heavily impastoed surface, and eerily representational effect, the painting has an uncanny air: it calls the viewer's attention to a specific moment in the face of flux and change. But the mood is detached, slightly mysterious. The time is late summer, as we can tell from the blooming sunflowers and asters. From the direction that the

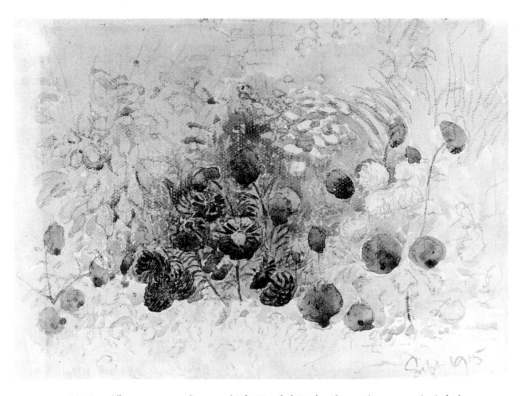

MacDonald's preparatory studies towards The Tangled Garden *(page 75) were extensive in both black-and-white and colour. This sketch conveys the animated arrangement of the crowded garden.*

J.E.H. MacDonald
Watercolour and graphite on paper, 11.1 x 15.7 cm
Private Collection, London, Ontario

sunflowers have turned to follow the sun, we can see that it is morning. Sunlight falls on the sunflower in the foreground and on the asters in the middle ground, making them luminous. The scene recalls a stage set and the viewer feels as though a drama is about to be played out.

A drama was unfolding, in fact, one that involved the creation of a new sensibility by a group of like-minded artists who in 1920 became the Group of Seven. MacDonald took a major role in the shaping of that group and helped charge it with optimism and vigour. *The Tangled Garden* reveals something of the essence of this new direction. It shows us a garden as a place of bold effects and monumental scale – "Grandeur, Height, Space, Life itself," MacDonald wrote in notes for a lecture he gave on Canadian art in 1930, outlining the qualities he considered crucial to a painting. With its broad, rich treatment and strongly designed forms, *The Tangled Garden* reveals the dignity of a simple subject powerfully realized. The garden becomes a lost empire of the imagination; its suggestion of wild nature embodies the essence of what these artists thought of Canadian life, suffused with a sense of grand scale. "Think big, be generous ..." MacDonald told students.

Notwithstanding its powerful originality, *The Tangled Garden* is a catalogue of influences. MacDonald was stimulated by his reading of the art writers of the period, particularly by the English critic and artist, John Ruskin. Ruskin had advocated the selection of rough, worn and clumsy-looking things as artistic subjects. He believed that they revealed the mystery that lies at the heart of nature. MacDonald drew on such ideas for *The Tangled Garden* (notice the worn boards of the house at the rear of the scene). He borrowed from Scandinavian and Chinese painting, too, and he echoed Vincent van Gogh in the dynamic colour, strong design and forceful brushwork. Reference to the Art Nouveau style, so popular at the turn of the century and part of his general heritage as an artist, is suggested through the bend in the shape of the main sunflower in

The Tangled Garden. The dense arrangement of botanical forms brings to mind the design principles of the British artist William Morris of the Arts & Crafts Movement.[1] But all such references are at a distance. More than anything, MacDonald's debt in this sensuous painting was to the natural world.

The oil and pencil sketches MacDonald made for this great painting reveal that his conception of *The Tangled Garden* evolved over a long period, changing shape and format. The idea of flowers kindled his imagination and he explored the subject both before and after making this painting. One stimulant – the one that kept his attention circulating throughout all these works – was colour. All MacDonald's oil sketches of flowers celebrate the mixture of hues he discovered in nature, the varying tones of yellow, green, red and white. Another inspiration was light: the way light illuminates colour and creates shadow patterns (see, for example, his sketch *Thornhill Garden, No. 1* in which shadows dapple the wall).

A third stimulant, one that is particularly apparent in his pencil sketches, was the shape of the flowers themselves. MacDonald's careful markings of graphite on paper prompt consideration of how human consciousness edits and constructs the world. Infatuated with their shapes, MacDonald studied one flower at a time, drawing them on a single sheet of paper and identifying and often dating the result. With care and attention, he recorded different varieties, collecting them for future use.

The specific oil studies for *The Tangled Garden* reveal the ways in which he drew on the small close-up sketches in the process of creating his larger finished painting, and they document the changes he made: a more careful design, additional detail, more plants, a more studied effect of light and dark. We can see how he developed the bent-over central sunflower into a stronger shape to set up the design of the composition and suggest the effect of height that MacDonald felt was important.

The composition was worked out in an oil sketch, now in the

GARDEN, THORNHILL, 1916?

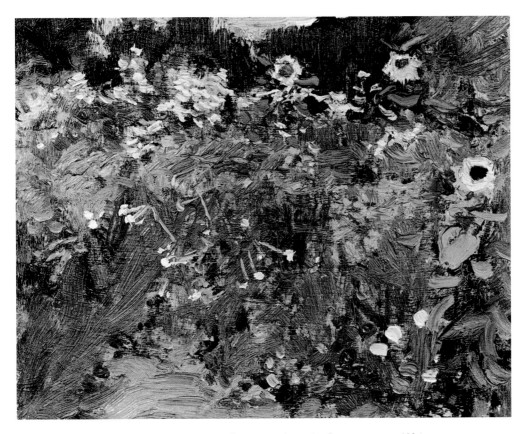

*In this spirited sketch, in which sunflowers soar above other flowers, MacDonald brings
information, feeling and visual beauty into effective alignment.*

J.E.H. MacDonald
Oil on board, 20.3 x 25.4 cm
The Thomson Collection, Toronto (PC-667)

collection of the National Gallery, which conveys a fresh and lively view and a sophisticated colour structure. In a lecture he gave on "The Decorative Element in Art" at Toronto's Arts & Letters Club in 1920, MacDonald discussed his ideas: by "decorative art," he meant the element "in which art lives and moves and has its being." For MacDonald, decorative art had three principles, broadly considered: rhythm included repetition and rhythmic alternation; balance referred to symmetry, contrast, proportion and spacing; and harmony included congruity and unity. In *The Tangled Garden* he connected the parts of the painting through rhythm, expressed in the repetition of lines or shapes; he achieved balance through the opposition of shapes and tones; and he created unity by making the form and idea coherent and complete.[2]

When *The Tangled Garden* was first shown at the Ontario Society of Artists, MacDonald was singled out for criticism by a leading critic of the day, Hector Charlesworth. Charlesworth wrote in *Saturday Night* that MacDonald threw "paint pots in the face of the public" and suggested that the size of the canvas was too large for the importance of the subject. He commented on what he considered to be the crudity of the colours. In a reply in the *Toronto Globe* titled "Bouquets from a Tangled Garden," MacDonald accused Charlesworth, among other things, of being ignorant of the topography of the country. He concluded by stating that *The Tangled Garden* and many other paintings are but "items in a big idea, the spirit of our native land. The artists hope to keep on striving to enlarge their own conception of that spirit."

Notwithstanding its beauty and power, the painting offers some challenges for contemporary viewers. These have to do less with the work itself than with the increasing distance between the Canadian past and the present, making the painting less specific and urgent. Ironically, the sense of power in the work is a drawback, too – in a way it seems almost to overwhelm its simple subject.

Drawings in Sketchbook, 1914–1922

Eighty-seven drawings in graphite and pen-and-ink, two loose drawings and five tipped-in
drawings in graphite on onion-skin paper, on ninety-four sheets of woven paper

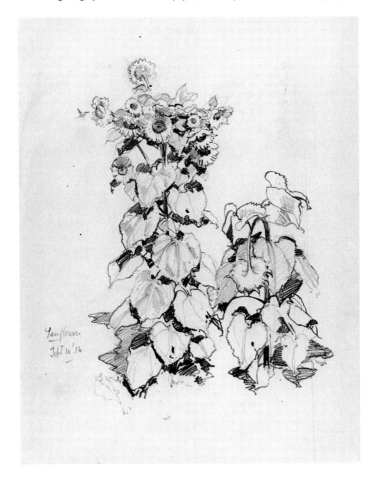

Sunflowers, September 10, 1916

*MacDonald enjoyed making detailed studies of flowers and focused on the
rich flowering at the top of the sunflower.*

J.E.H. MacDonald
Graphite on paper, 23.6 x 18.9 cm
National Gallery of Canada, Ottawa (18906)

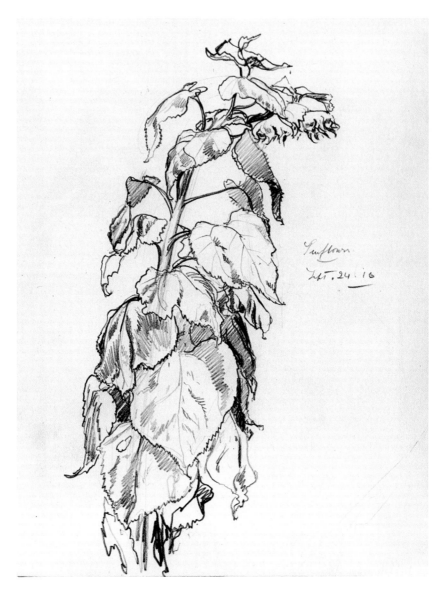

SUNFLOWERS, SEPTEMBER 24, 1916

MacDonald was interested in capturing the rhythmic structure of the sunflower.

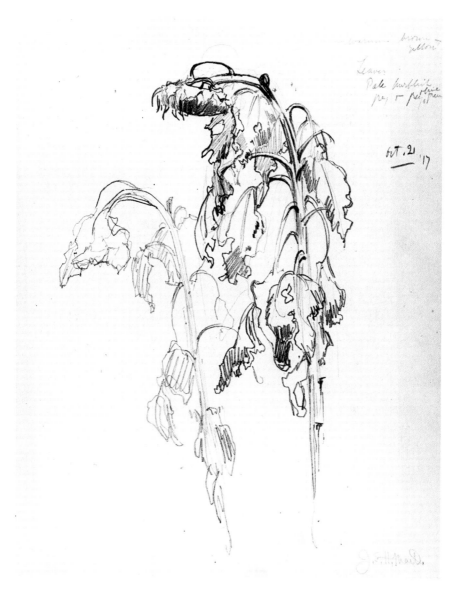

SUNFLOWERS, OCTOBER 21, 1917

MacDonald captured the bending heads of the sunflowers and the large, floppy leaves.

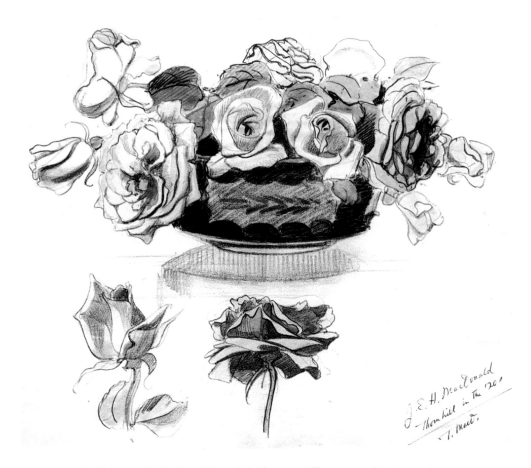

In this later study, MacDonald has included flowers at different stages of development beneath
the carefully studied bowl of roses. "Thornhill in the '20s," noted his son,
Thoreau MacDonald, in pen at lower right.

J.E.H. MacDonald
Watercolour and pencil, 18.8 x 21.9 cm
Private Collection

These quibbles aside, we can only admire the scope of MacDonald's imagination. He was an innovator, a brilliant designer and a masterful painter, and he took great joy in applying his talents to other floral subjects he found close at hand. These ranged from still lifes of asters in a Chinese vase to flowering orchards, which he captured during that happy time of year, the spring season. He loved the energy of flowers – they astounded him. That the shape of the monumental sunflower in the foreground of *The Tangled Garden* could be related to the Art Nouveau style must have pleased him, but that knowledge mattered less than the way its lampshade form directed energy into the picture, its force echoed and varied by shapes and colours throughout the painting.

All MacDonald's paintings emphasize images of vitality and growth rendered with flat pattern, heightened local colour, and simple but dynamic composition. *Asters and Apples*, which he painted in 1917, tapped into the rich vein he had created. The view, with its gnarled old tree, shows the same section of the garden depicted in *The Tangled Garden*. Apples have fallen on the lawn; the time is late summer or early autumn. Like *The Tangled Garden*, this work is luxuriously disordered and filled with rhythmic repetitions. Yet the result, though fully as decorative, is less an epic than an ode. Still a celebration of nature, *Asters and Apples* is less ambitious than MacDonald's big-statement painting, more an expression of the private man. "Now the war overshadowed everything and M. (MacDonald) felt much oppressed by it as well as various financial worries," his son, Thoreau, recalled much later.

In November 1917 the MacDonald family had to rent out their home in Thornhill and move to a small and rickety house in York Mills. The night after moving, while all was still in disorder, MacDonald suffered a complete collapse – probably a stroke – and was unable to get up for many months. A certain aura colours the mood of *Asters and Apples* – the fallen apples among the grasses stir thoughts of the decay of the year, of

endings and death. The painting, it would seem, is MacDonald's farewell to his home.

Always interested in expanding his formal vocabulary, MacDonald continued to make many drawings of flowers. One senses his joy in the shapes he discovered: the sunflowers drawn that October, the poppies in 1920 practically wandering off the page, the rose, the poppies, the wake-robin. He conceived of art as a continuing narrative and the subject of flowers was one he wanted to understand, inch by inch. Some of his drawings are delicate; some possess a dynamic energy. His pre-vailing mood was genial, one of thoughtful investigation. In the end, MacDonald's concern for flowering life stirs empathy. In his sketchbook, he recorded the works he gave to his framer, A.J. Boughton, on March 13, 1916: six landscapes and twenty-six flowers. Clearly, he had delved into the fertile garden of art and come up with a subject that touched and inspired him, and one that would have its effect on his painting partners as well.

That MacDonald was so deeply moved by garden and floral imagery tells the viewer a great deal about why he was so taken with a flower sketch by Tom Thomson, *Marguerites, Wood Lilies and Vetch* that he asked that a reserve be placed on the work (he wrote on the back "*Not For Sale*"). This study of a woodland bouquet, with its graceful design and beautiful colour, is one of the most successful floral paintings in Canadian art and one of Thomson's greatest works. The ferns to the left and right form a V-shaped receptacle for the marguerites and vetch; the colour is constructed with equal care. Note the way Thomson uses pink at the upper right, the centre and the upper left, and the way he dabbed in black to indicate the background space. One yellow flower hanging off-side to the left lends a note of veracity.

What distinguishes Thomson's work from MacDonald's is its elegant, slightly funky form and throwaway spontaneity. Of course, this painting

by Thomson is in the sketch medium, so his intention was different than MacDonald's. But even if we compare the Thomson sketch with the study for *The Tangled Garden*, the contrast is striking: Thomson's sketch is much more abbreviated and focused than MacDonald's. Thomson used only a few flowers in *Marguerites, Wood Lilies and Vetch* and they press close against the edge of the picture plane as if they are growing in an imaginary out-of-doors space set immediately in front of the viewer. Thomson does not attempt to convey a believable arrangement of light and shade; he simply places his bouquet against a dark background, making the flowers look more brilliant and vibrant. This also adds to the sense of immediacy.

There are other differences. Besides being very simply handled, Thomson's painting adds to his floral subject a surface calligraphy of grasses and stems, developing variations between the bold and the delicate. And the flowers in Thomson's painting are true wildflowers, which the artist had painted in Algonquin Park, a specifically northern location. The resonance of such a place meant much to the Group of Seven. It promised to fulfill their intention of discovering the spirit of their native land and the dream, common to utopian Modernism, of a pure new beginning.

Thomson painted many other bouquets and sometimes we can pick out the kinds of flowers he used in his paintings (or let other people do it for us, since Thomson-watching has become a national sport). In *Wildflowers*, even the amateur can spot Indian paintbrush. In *Orchids, Algonquin Park*, the famed lady's slipper orchid appears with its conspicuous "lip," which secretes nectar, and its broad leaves. In *Water Flowers*, the flowers may be pickerel weed, white water lilies, and what may be yellow lilies (the second word after "yellow" is illegible on the back of the sketch). The date, 1916, is also given, pencilled there by Thomson's friend, Dr. James MacCallum. This sketch is even more spontaneously painted than *Marguerites, Wood Lilies and Vetch*. Here, Thomson

modelled the shapes in a more summary fashion, simply blocking in his yellow flowers, the pad, the rushes and weeds. He probably wanted a different effect, more involved with colour harmony – in this instance, a harmony of browns, golds and greens. In 1916, too, he was preoccupied with developing a more concise look to some of his forest scenes, perhaps to experiment with abstraction. Indeed, the general effect of *Water Flowers* is more abstract.

Elsewhere, Thomson's work centred on nature's big moment of flowering during springtime and summer, gravitating to the graceful wild cherry trees white with flowers or the yellow water lilies he saw floating on the waters of Georgian Bay or in Algonquin Park. His most innovative work was done casually, as though he were investigating a variety of approaches to a theme. MacDonald, a painstaking designer, must have envied Thomson's gift of moving effortlessly over terrain he himself was covering.

The theme of *The Tangled Garden* led to many repercussions in the Group of Seven. Most conspicuously, MacDonald's great painting gave permission to the members of this special band to paint their own versions of domestic nature, tapping not so much MacDonald's imagery as the spirit of his painting. Lawren Harris, for instance, painted flowering trees in *Chestnut Trees, House, Barrie*, the year after *The Tangled Garden*, to celebrate the powerful forms of this distinctive tree so often seen on city streets. Harris's branches arch directly in front of the picture plane, laden with leaves divided into about seven radiating leaflets and showy erect clusters of white flowers. The painting resonates with an emotional and formal power of Harris's own devising, one similar to MacDonald's in the crispness and monumentality of its definition and in its dramatic lighting. *Spring*, painted in 1920 by Franklin Carmichael, is based on the general structures and ideas of Tom Thomson and the Group of Seven and not on any specific relation to MacDonald's work.

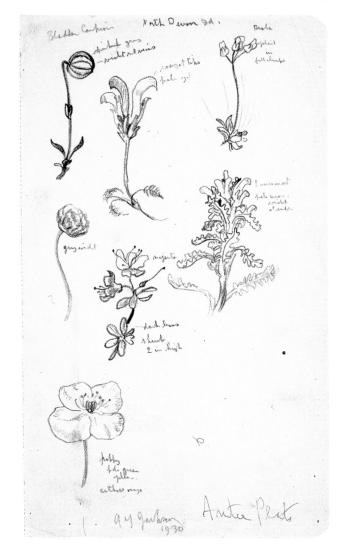

A.Y. Jackson
Graphite on paper, 28.0 x 14.0 cm
Firestone Art Collection: The Ottawa Art Gallery (FAC 0571)
Donated by the Ontario Heritage Foundation to the City of Ottawa

Maple Buds in a Vase, 1953

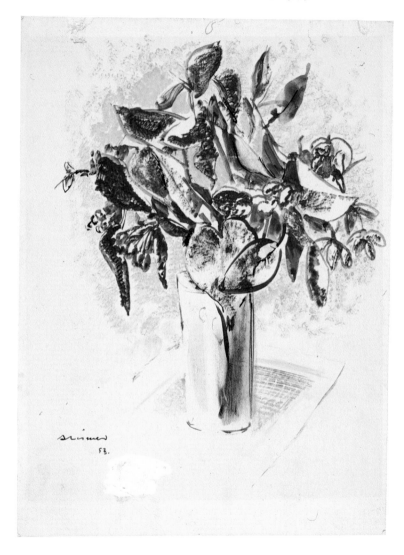

Arthur Lismer
Gouache, ink, graphite, pencil crayon on cardboard, 30.4 x 22.9 cm
Firestone Art Collection: The Ottawa Art Gallery (FAC 0799)
Donated by the Ontario Heritage Foundation to the City of Ottawa

A.J. Casson
Graphite on paper, 27.4 x 20.9 cm
Firestone Art Collection: The Ottawa Art Gallery (FAC 0204)
Donated by the Ontario Heritage Foundation to the City of Ottawa

Untitled [Geraniums and Trees], 1935

A draftsperson and artist of rigorous intelligence, FitzGerald presents in this drawing a conception of intricate complexity clothed in an austere vocabulary.

Lionel LeMoine FitzGerald
Graphite; white chalk highlights; pencil crayon on paper, 35.5 x 32.0 cm
The McMichael Canadian Art Collection, Kleinburg (1993.19.6)
Gift of the Founders, Robert and Signe McMichael

But, again, MacDonald's example paved the way. In other works, like Carmichael's print *Pencilled Irises* with its general effect of upthrust and close-up view, he tilled new ground.

A.Y. Jackson, another member of the Group of Seven, also painted flowers, a theme he developed with formal clarity from an early date. In Paris around 1913 (the back of the canvas is stamped with the address of a Parisian art supply shop), he painted dahlias with strongly modelled shapes, thoughtfully picked out in shades of green. Set against a stark background, they have a sense of bold statement combined with an effect of spontaneity. In other works of approximately the same period, Jackson combined subtle tones with strong handling that indicate his pleasure in quiet scenes of formal beauty. The flowers in his *Blue Gentians*, for instance, are firmly modelled, particularly the flower in the front of the vase with its frame of green leaves; Jackson also carefully studied the china bowls in the painting to create a harmony in blue.

Painters associated with the Group of Seven, such as Frank (later Franz) W. Johnston, approached the subject of flowers only rarely. In an early work, a watercolour of water lilies, Johnston nevertheless shows his competence in the way he used the white of the bare paper to indicate the colour of the flowers. LeMoine FitzGerald sensitively, even tenderly, painted or drew indoor geraniums, usually set on windowsills. In one sketch, the artist has presented a view through the window of a snowy scene. As the inscription indicates, it was done the day before Christmas and sent as a gift to friends. Edwin Holgate also enjoyed painting flowers indoors (such as a view from above of an azalea plant atop a table). In his *At the Window*, he depicted a hyacinth plant indoors and contrasted it with the view outside the window of a passerby in the snow. F.H. Varley, in *Fireweed*, reacted brilliantly to the colour of outdoor wild flowers, creating an intricate and deliriously inventive design composed of an unusual colour scheme of pinky-purples, greens and orange-browns.

Arthur Lismer painted many works in Thornhill where he, like MacDonald, lived for a short period of time. He is one of the few to make a specific reference in his painting to MacDonald's great work. He would have been able to study the painting practically first-hand since MacDonald had given him the *Study for The Tangled Garden* in the autumn of 1916 (an inscription by MacDonald and the date are on the back of the sketch).

The garden paintings that Lismer created immediately after MacDonald's trailblazing work show his version of the subject. In his *Springtime on the Farm*, for instance, painted around 1917, the garden, enclosed by a picket fence, is much tidier. Lismer added another touch of life in the ducks that stroll beside the lilac trees. But much later, Lismer deliberately recalled MacDonald in his *Lilies and Apples*, painted in 1931. The painting has a private garden subject and tangled growth like MacDonald's *Tangled Garden* and also recalls MacDonald's *Asters and Apples* in the way Lismer contrasted the shapes of the apples with those of the flowers (here white and orange lilies).

A.J. Casson, like MacDonald, turned to the subject of flowers for continual enrichment. Taking a suggestion from Carmichael, he created many paintings and prints, some of mixed bouquets in jars, some of unpretentious studies of different species – oriental poppies, crocuses, wild roses – which convey the basic shape of the flowers close-up as if the viewer leaned over them for a better look. Such works have an informal quality: flowers or petals may lie on the table area as though they have fallen from the vase, as in *Bowl of Flowers*. To heighten the spontaneity, Casson favoured a snapshot view, cutting the shapes to the edges of his composition. He delighted in the pattern and design he was able to create using the subject; he liked cheerfully coloured images pervaded by an elegance, an economy of form and sensitivity to his material. He sometimes intended his prints also to serve as Christmas cards.

What is ultimately memorable about the works of the Group of Seven artists is the sheer impact of the paintings themselves. At their best, the flower subjects of these artists are startling in their power. Instead of fragility, we find energy and often monumentality, even when the paintings are modest in scale. The garden imagery of J.E.H. MacDonald, Tom Thomson and the Group of Seven took this group of artists into flourishing new territory.

NOTES

1. Perhaps, too, MacDonald also drew on ideas he had seen developed in a recent mural commissioned by his friend Dr. J.M. MacCallum, a commission in which he and Arthur Lismer had been joined by Tom Thomson who had painted stylized trees and forest growth. Charles C. Hill suggests that the stylization in Thomson's work for MacCallum recalls MacDonald's bending sunflowers in *The Tangled Garden* (Charles C. Hill, *Exploring the Collections: Bouquets from a Tangled Garden*, Ottawa: National Gallery of Canada, 1975, page 2).

2. Of the second principle, balance, MacDonald spoke of three definable forms: first an even balance of equal things on either side of an imaginary central line; second, a balance of apparently unequal things on a common centre; and third, a balance without obvious relation to a centre. His design in his great painting balances unequal things: the sunflower at the left provides more interest than the sunflower to the right, yet the use of unequal but similar parts suggests growth, unity, construction, to use MacDonald's words (J.E.H. MacDonald, "The Decorative Element in Art," talk given at Toronto's Arts & Letters Club, March 25, 1920, J.E.H. MacDonald Papers, MG30, D111, vol. 3, Ottawa: National Archives of Canada).

THE FLOWERS

LIST OF PLATES

(Where a title is duplicated, the collection is given.)

Franklin Carmichael, 1890–1945

Original member of the Group of Seven

Spring, 1920

The season of spring had long entranced members of the Group of Seven, who considered it a wonderful miracle. Something of this miraculous quality appears in Franklin Carmichael's painting of a grove of poplar trees, most of which are in bloom. Note the small flowers arranged along flexible stems to form single-stemmed clusters that hang limply like caterpillars from the little branches.

Carmichael's handling in this important painting of 1920 – the year the Group of Seven was founded – is particularly sensitive, lyrical and richly coloured. He considered the work one of his best and selected it to appear in the 1920 opening exhibition of the Group of Seven at the Art Museum of Toronto in May. In 1924, he exhibited it at the prestigious British Empire Exhibition in Wembley, England, and in 1936, at the National Gallery of Canada's Retrospective Exhibition of Painting by Members of the Group of Seven: 1919–1933. Megan Bice, the curator of *Light & Shadow: The Work of Franklin Carmichael* at The McMichael Canadian Art Collection in Kleinburg in 1990, suggested that in this painting Carmichael demonstrated his interest in contrasts: nearby trees with faraway hills and sky; aged trees with saplings; winter browns with spring greens. Along with these dialogues, Carmichael carefully recorded his optical perception of light and shadow.

Franklin Carmichael
Oil on canvas, 92.2 x 76.8 cm
Private Collection

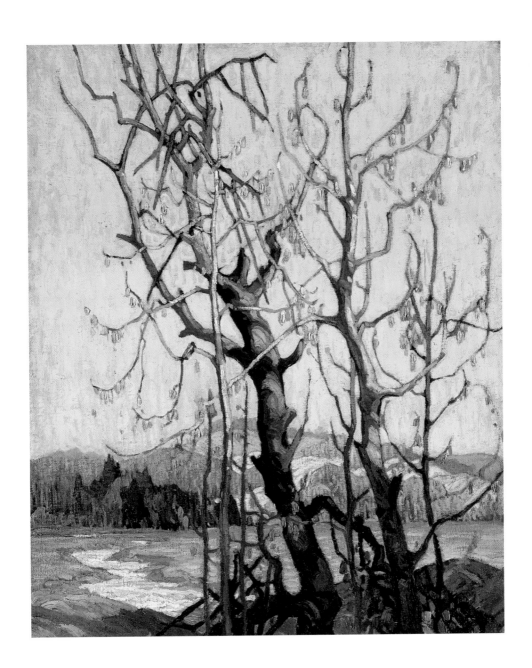

PENCILLED IRISES, C. 1930S

Carmichael was a master printmaker with a sure sense of graphic design. In this linocut he captured the delicacy and intimacy of flowers – a subject rarely found in his paintings. The print is complex and contrasts the linear markings of the plant with a dark background. Flowers look monumental here, like forces of nature. The strength of this work is in its powerful yet well-composed immediacy.

Ian Thom, who examined Carmichael's print production in a 1984 exhibition, wrote that Carmichael often chose flowers as the subject of his prints, although they were rarely seen as a subject in his painting.

Franklin Carmichael
Colour linocut on laid paper, 22.2 x 16.5 cm (image),
30.6 x 20.6 cm (sheet)
National Gallery of Canada, Ottawa (36871)

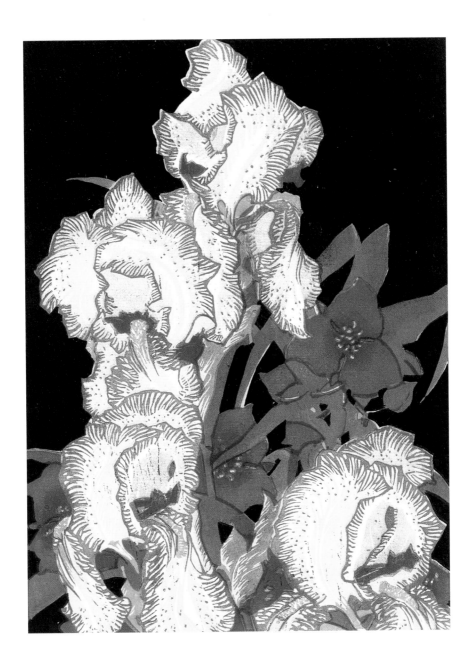

A.J. Casson, 1898–1992

Member of the Group of Seven in 1926

Summer Flowers; Centre Island, 1923

Among the Group of Seven, Casson was the artist who most clearly shared MacDonald's passion for flowers, painting them or using them in paintings or silkscreens with undiluted pleasure throughout his long artist's life. His work is studded with gems like this gentle record of summer flowers on Toronto's Centre Island.

A.J. Casson
Oil on board laid down on panel, 23.5 x 28.6 cm
Private Collection

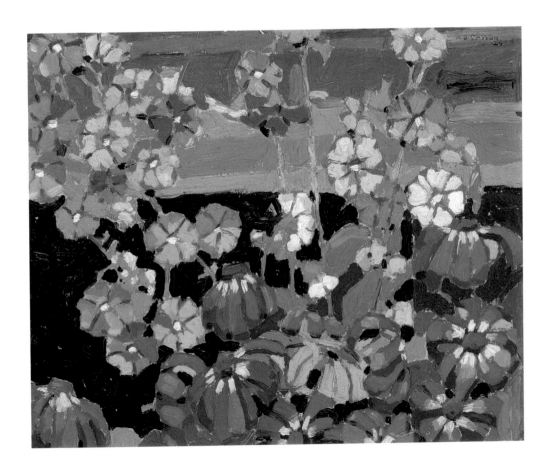

Bowl of Flowers, c. 1925

This vigorous image with its full colouring is likely one of Casson's earlier silkscreens. His work in this medium often was on a small scale and elegantly crafted. Ultimately, the hows and whys of a specific print seem to matter less than the cheerful atmosphere generated by this piece and others: flowers in a bowl, often with one or more fallen petals lying on a tabletop.

A.J. Casson
Silkscreen on paper, 22.9 x 26.7 cm (image),
26.0 x 29.1 cm (sheet)
Private Collection

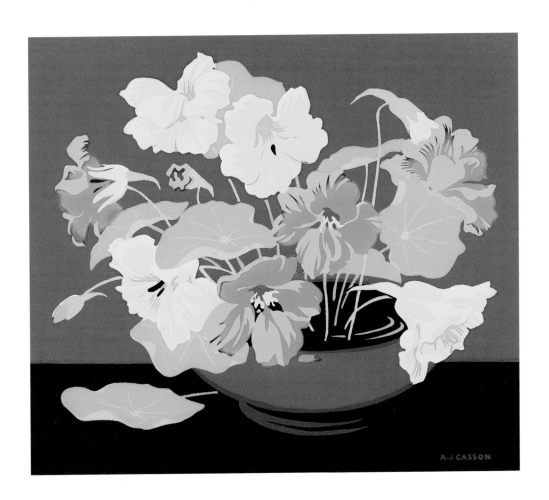

CROCUSES, C. 1927

Crocuses is one of Casson's happiest silkscreen prints and provides an excellent example of his typical close-up view, here one drawn from flowers in nature. The print reminds us that Casson devised new images for the Group of Seven: as a true lover of the botanical world, he tactfully recorded disparate organic forms, capturing their random appearance.

A.J. Casson
Silkscreen print, 18.4 x 15.7 cm (image),
30.3 x 25.6 cm (sheet)
Private Collection

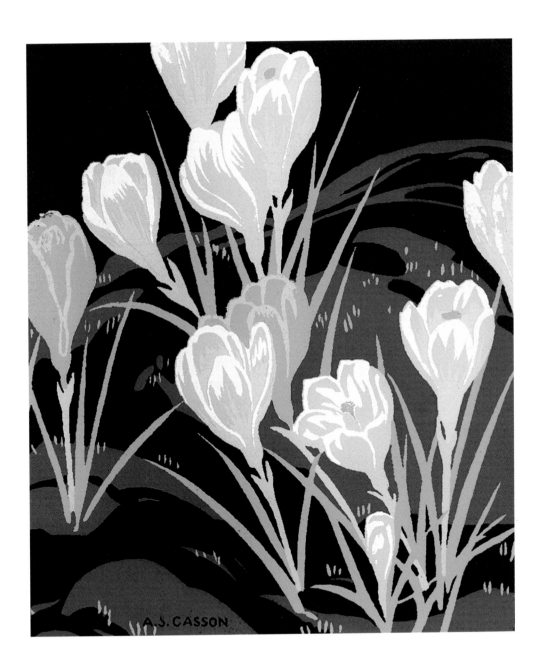

Mixed Bouquet, c. 1930

On the back of this engaging painting Casson wrote "*I made this tempra* [sic] *painting – titled 'Mixed Bouquet' – of Delphiniums, Baby's Breath and Single Marigolds in 1930 or close to that date. A small edition of serigraphs was made from it.*"

Always fresh and seemingly spontaneous, Casson's work is drawn with deftness and consistency. His use of colour is similarly bright and inventive. Clearly, for him printmaking offered a challenging way to combine realism and emotion with a strong sense of the medium's potential.

A.J. Casson
Tempera on paper, 26.7 x 21.6 cm
K.W. Scott, Q.C., Toronto

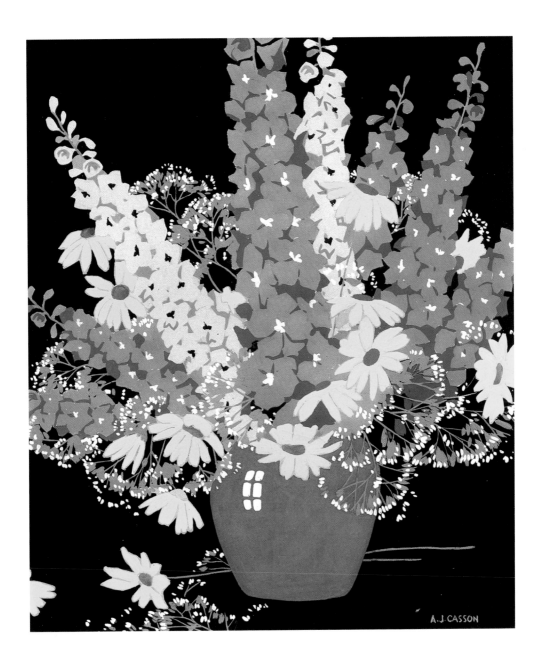

Wild Roses, c. 1940

In some of his later works, Casson printed on wood veneer, no doubt enjoying the way the result distantly recalls Tom Thomson's paintings on plywood. In Casson's work, as in Thomson's, design plays a crucial role in assisting the subtle but complex result.

A.J. Casson
Silkscreen on wood veneer, 24.2 x 28.8 cm
Private Collection

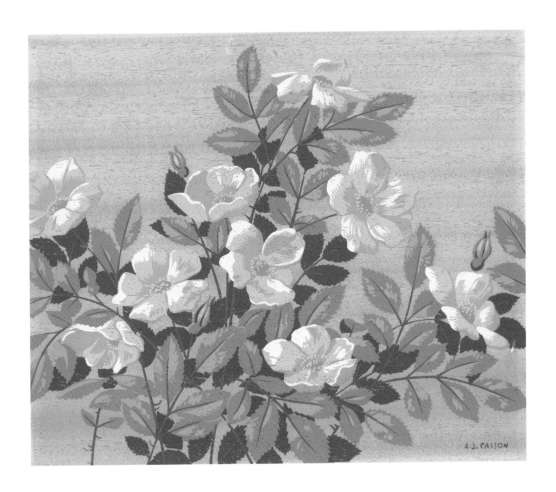

LIONEL LeMOINE FITZGERALD, 1890–1956
Member of the Group of Seven in 1932

GERANIUM IN WINDOW, 1948

FitzGerald's perspective on flowers reflects everyday moments from his own life, as in this depiction of a geranium at a window. In this painting, FitzGerald turns a still life into something of a landscape by suggesting the world outside the window. His technique during this year of his work was to use small stipples – they allowed him to modulate tone and suggest abstract qualities of form.

Lionel LeMoine FitzGerald
Watercolour on paper, 61.0 x 45.7 cm
The Winnipeg Art Gallery (G–75–14)
Gift from the estate of Florence Brigden

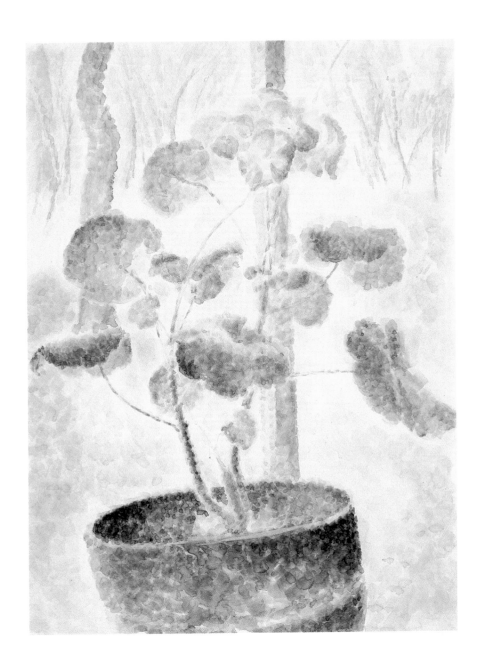

LAWREN HARRIS, 1885–1970
Original member of the Group of Seven

CHESTNUT TREES, HOUSE, BARRIE, 1916–1917

Perhaps inspired by the size and grandeur of J.E.H. MacDonald's
The Tangled Garden, Harris in this painting depicted a well-known city
tree, the chestnut, in its spring flowering. Quiet and deliberation were
Harris's essential ingredients, combined with a perfect mastery of form.
The result is one of the unique compilations of precise little observations
that together make a record of the value of seeing.

Most of Harris's other paintings during this period were of snow and
they reflect a debt to Scandinavian prototypes he had seen in a show of
Contemporary Scandinavian Art in Buffalo in 1913. In his snow series,
he had moved from naturalism to a more decorative treatment. *Chestnut
Trees, House, Barrie* also displays a richly decorative approach, with an
emphasis on flat, two-dimensional patterning and a simple but powerful
composition. These qualities demonstrated his feeling for the new artists'
community, which in 1920 became the Group of Seven.

Lawren Harris
Oil on canvas, 113.0 x 111.6 cm
McGill Visual Arts Collection, Montreal

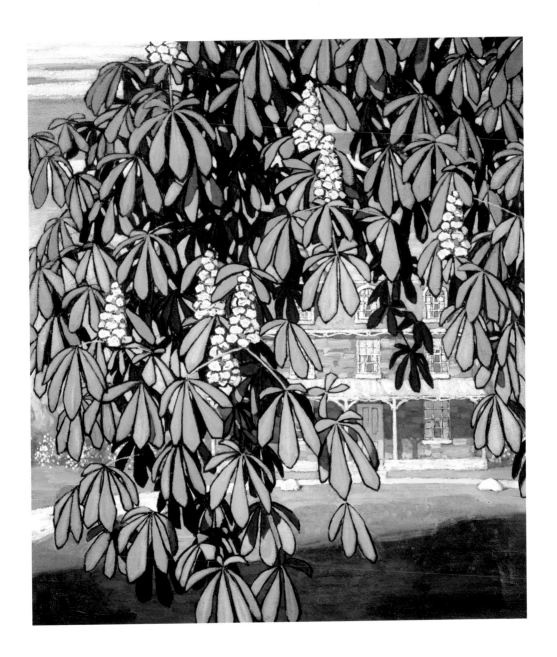

EDWIN HOLGATE, 1892–1977
Member of the Group of Seven in 1931

AZALEA, 1934–1944

Holgate saw reality as something to be recorded or inspected, not changed or adorned. In his painting of an indoor plant, there is something celebratory; he takes on a genre everyone is an expert in but invests it with his own analytic and objective insight.

Edwin Holgate
Oil on canvas, 53.3 x 46 cm
Montreal Museum of Fine Arts (1987.5)

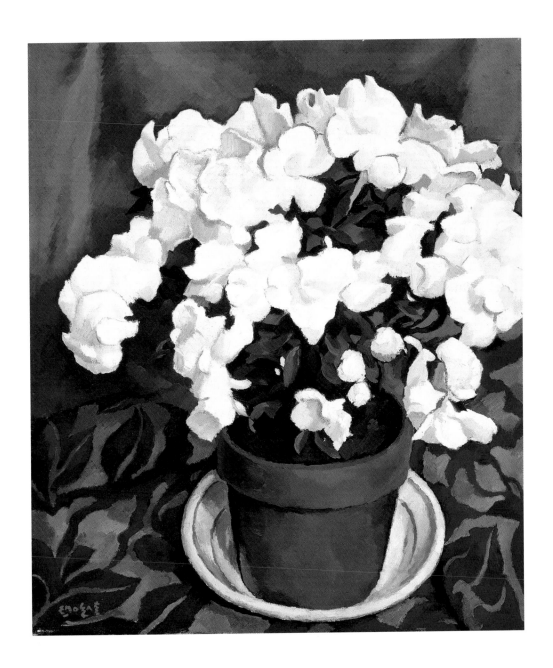

At the Window, 1935–1945

Holgate's imagination and craftsmanship are obvious in this painting of an interior/exterior world. In the painting, Holgate captured truth on a level deeper than surface appearance.

Edwin Holgate

Oil on canvas, 53.3 x 45.7 cm

Montreal Museum of Fine Arts (1988.24)

Gift of the estate of Dr. Max Stern

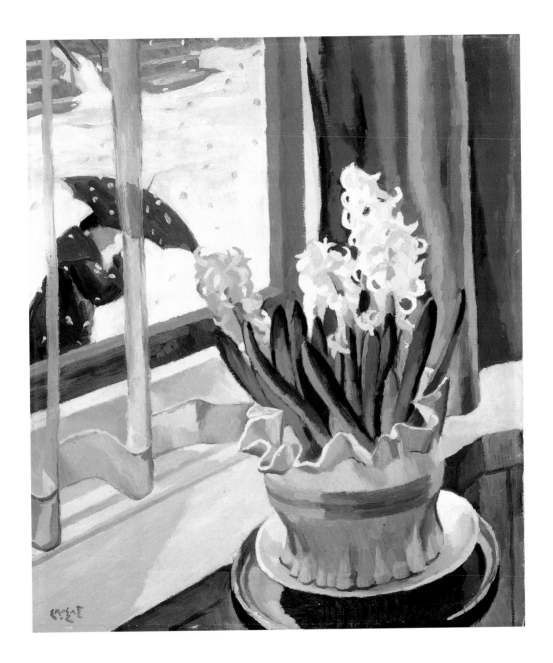

A.Y. JACKSON, 1882–1974

Original member of the Group of Seven

BLUE GENTIANS, 1913

A trailblazer in forming the Group of Seven, Jackson here applied his interest in paint qualities to a still life. The richly and subtly coloured result has a coherent composition and constitutes one of his finest early works.

Critic Hector Charlesworth wrote of the painting in *Saturday Night* in 1924 that it was "one of the most delicate and beautiful achievements in still life that has been seen in recent years." The picture was painted during the summer while Jackson was visiting his cousins, the Clements, and their friends, the Williams, at Georgian Bay. Later, Jackson told his niece Naomi Jackson Groves that he had painted it for Esther Williams (she donated it to The McMichael Canadian Art Collection in Kleinburg in 1988). The painting was one of Jackson's favourites and he often used it in exhibitions.

A.Y. Jackson
Oil on canvas, 53.0 x 48.3 cm
The McMichael Canadian Art Collection, Kleinburg (1988.24)
Gift of Miss D.E. Williams

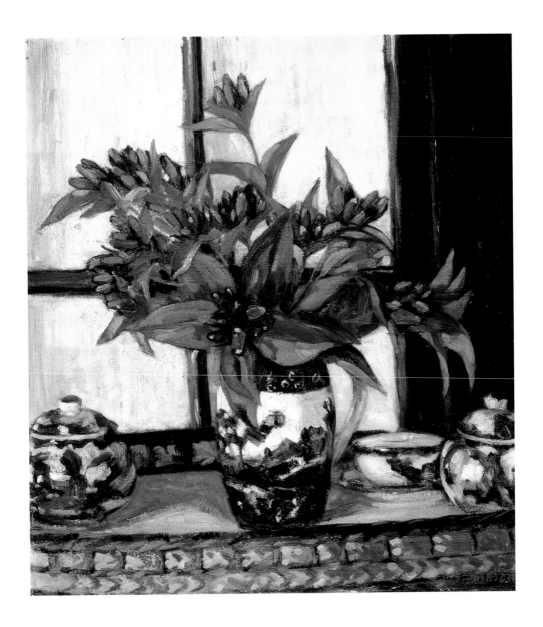

DAHLIAS, C. 1913

The painting provides an illuminating glimpse of certain qualities in the work of A.Y. Jackson that are not as well known in his landscapes. Here he has created an engaging, easel-size picture that suggests his formal background in art schools in Chicago and Paris. On the back of the painting is the rubber stamp of the Paris American Art Co., 125 Boul. du Montparnasse, Paris. An atmosphere of mystery is generated by the evocative flowers.

A.Y. Jackson
Oil on panel, 32.6 x 40.7 cm
The McMichael Canadian Art Collection, Kleinburg (1968.17.2)
Gift of Mr. S. Walter Stewart

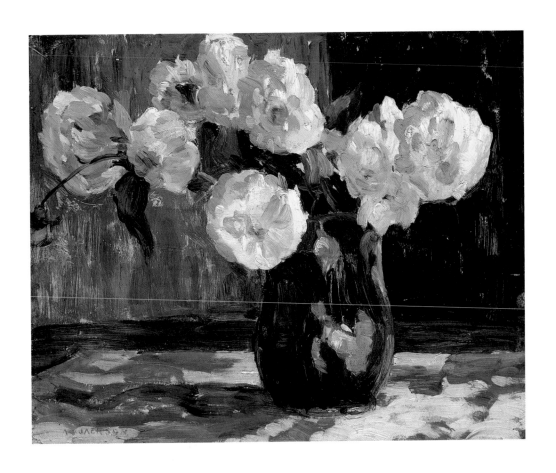

Frank H. (Franz) Johnston, 1888–1949

Original member of the Group of Seven; only showed with first exhibit

Water Lilies, [date unknown]

In this delicate watercolour, Frank H. Johnston displays his interest in flowers found in nature. His viewpoint has an oddly mysterious playfulness – it suggests that he painted the work from a canoe.

Frank H. (Franz) Johnston

Watercolour over graphite on paper, 20.3 x 20.3 cm

The McMichael Canadian Art Collection, Kleinburg (1974.15)

Gift of Mrs. J.M. Bowman

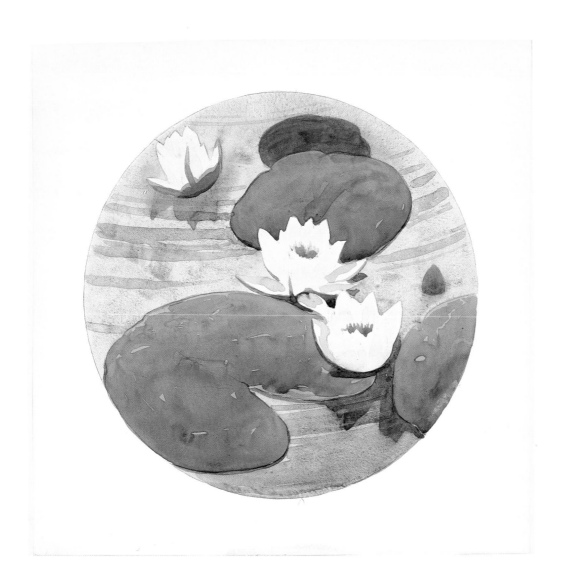

ARTHUR LISMER, 1885–1969
Original member of the Group of Seven

SPRINGTIME ON THE FARM, C. 1917

In this painting, Arthur Lismer has produced in loving detail the happy
atmosphere of spring on a farm in the Nova Scotia countryside. He
presented a scene filled with incident, from the shadows of trees set in
the viewer's space (a motif borrowed from A.Y. Jackson) to the ducks
waddling beside the garden area, a ladder leaning against a branching
apple tree and lilac bushes beside the fence. In the distance are two barns,
one with an open door. Among the treats in this picture: the green shadow
of the trees and the puffy clouds. The narrative is never quite spelled out,
but the different elements have a commanding grace that confirms, like
much else in Lismer's work, that an ebullient spirit rules.

Arthur Lismer

Oil on canvas, 30.4 x 40.6 cm

Montreal Museum of Fine Arts (1956.1124)

Gift of the A. Sidney Dawes Fund

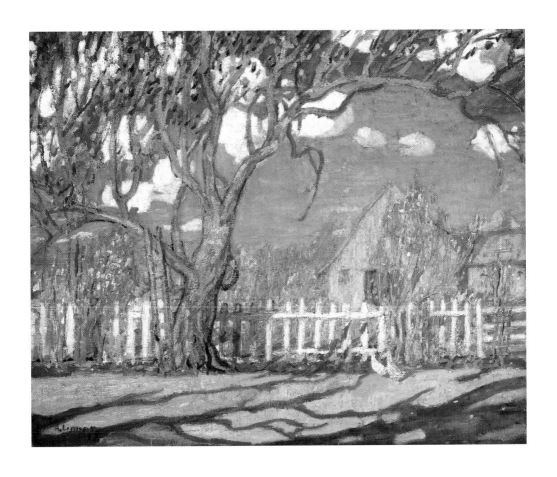

LILAC TIME, C. 1917

A rich chromatic colour range dominates this painting. The picture, probably painted at much the same time as *Springtime on the Farm* (page 55) makes a persuasive case for the subject's vast, maybe limitless potential.

Arthur Lismer
Oil on panel, 23.0 x 30.5 cm
Art Gallery of Nova Scotia, Halifax (1977.56)
Partial gift of Doreen Fraser, Halifax, Nova Scotia, 1977

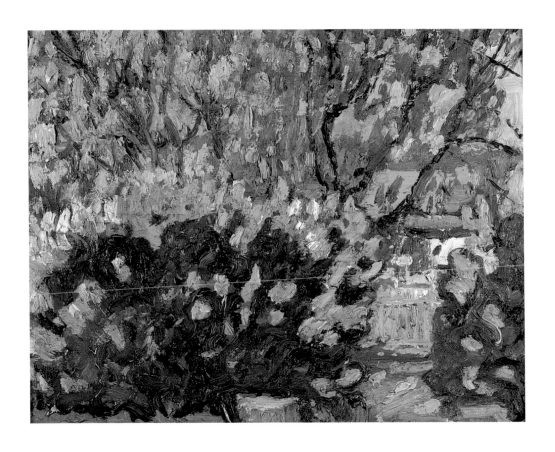

Lilies and Apples, 1931

Lismer is one of the few artists to closely echo MacDonald's work; here, as though in memory of MacDonald's *Asters and Apples* (page 83), he has painted *Lilies and Apples*, although he has given the subject his own bursting energy and a deft and touching simplicity.

Arthur Lismer
Oil on cardboard, 30.7 x 40.5 cm
National Gallery of Canada, Ottawa (4892)

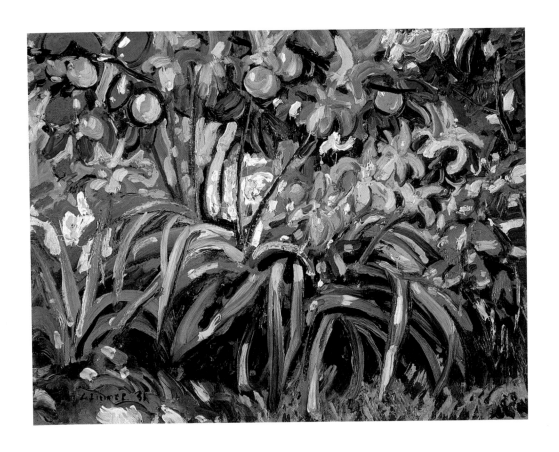

Pots of Flowers, 1938

Lismer's *Pots of Flowers* is animated by an antic wit. It is saved from an overcrowded effect by the contrast between the containers and the flowers.

Arthur Lismer

Watercolour, 33.0 x 50.8 cm

Rodman Hall Arts Centre, St. Catharines

Gift of Mr. and Mrs. C.S. Band in memory of Mrs. C.M. Hill, 1964

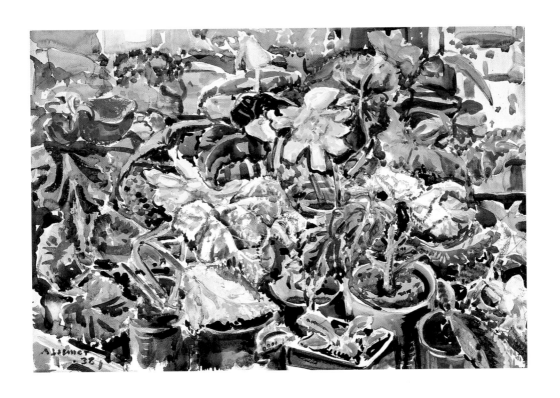

J.E.H. MacDonald, 1873–1932
Original member of the Group of Seven

Asters, c. 1914–1915

The minute you see MacDonald's flower subjects you know you are in a different world from the rest of the painters of the Group of Seven. Where their work is an art of controlled space, his paintings are spare and airy. His contribution to the flower subject in Canadian art is outstanding. Note the Chinese vase MacDonald used to hold his asters; it appears again in *Asters in a Window* (page 65).

J.E.H. MacDonald
Oil on board, 25.0 x 20.0 cm
Private Collection

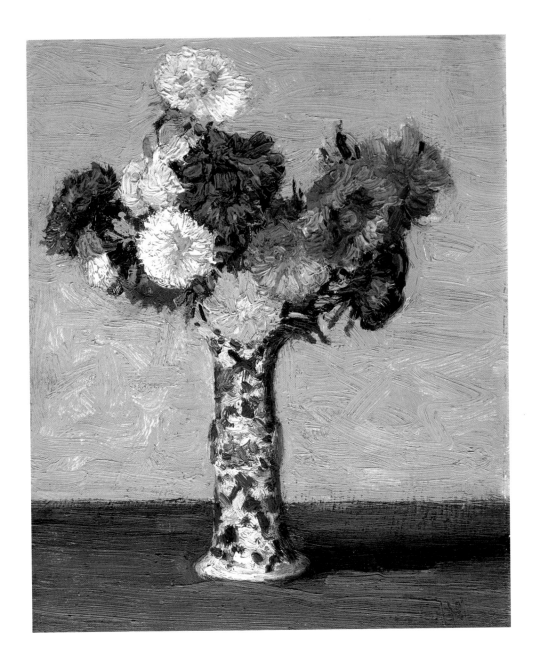

Asters in a Window, c. 1914–1915

This painting, a variant on a favourite subject of MacDonald (page 63), is painted with exceptional flair. What it's really about is the space surrounding the vase, in which vase and flowers, and the apples at lower left, breathe like living things, vital and buoyant.

J.E.H. MacDonald
Oil on panel, 20.3 x 25.4 cm
Private Collection

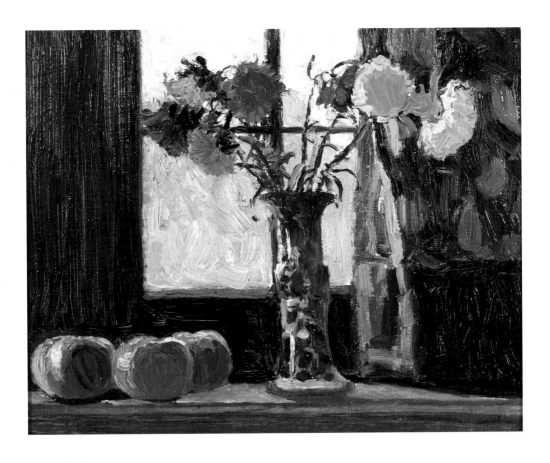

Garden Flowers, c. 1915

Among MacDonald's outstanding floral studies is this small but powerful sketch from his garden. In it, he has captured the diverse shapes and colours of flowers (possibly among them are foxglove and gladiola), along with their joyous energy.

J.E.H. MacDonald
Oil on panel, 20.0 x 14.6 cm
Private Collection, Toronto

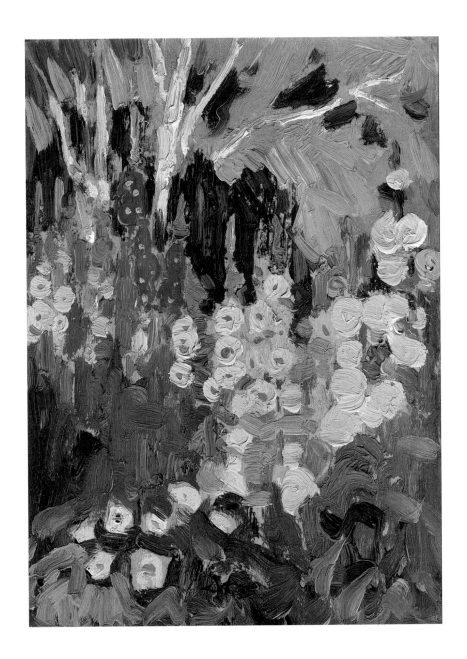

MacDonald captured diverse moments of his garden's life to later compose *The Tangled Garden*; this sketch is the one with the most detail related to the famous painting. Although the material is in the sketch format, its anarchic energy still generates excitement.

J.E.H. MacDonald
Oil on cardboard, mounted on plywood, 20.5 x 25.0 cm
National Gallery of Canada, Ottawa (4626)
Gift of Arthur Lismer, Montreal, 1946

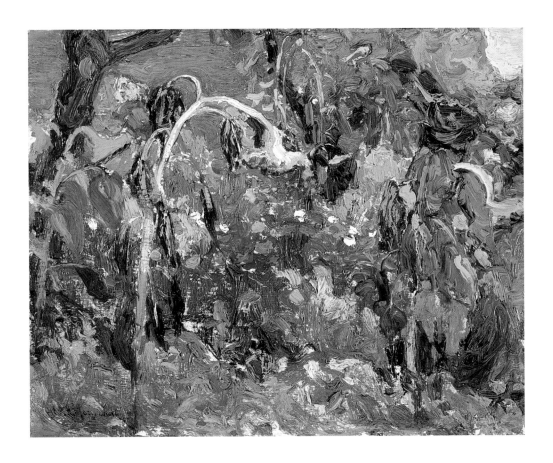

Sunflower Garden, 1915?

The panel conveys the transverse effect of MacDonald's garden and its sense of crowding. Both these qualities made their way into his great painting, *The Tangled Garden* (page 75).

J.E.H. MacDonald
Oil on panel, 20.3 x 25.3 cm
The McMichael Canadian Art Collection, Kleinburg (1968.8.1)
Gift of Mr. S. Walter Stewart

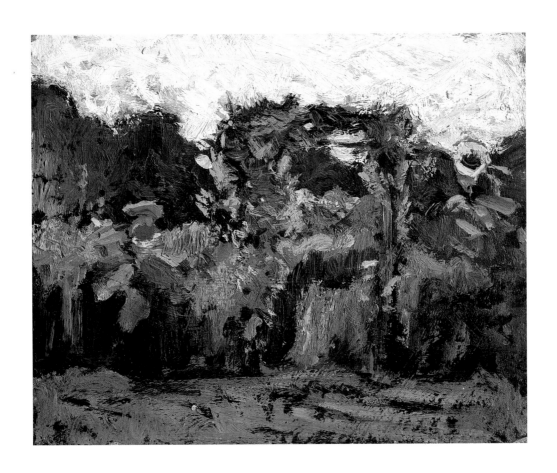

Sunflower Study, Tangled Garden Sketch, 1915?

This brushy study seems closely related to one of the sunflowers in MacDonald's *The Tangled Garden* (page 75). It captures the sense of movement and sunlit presence of one of MacDonald's favourite painting places.

J.E.H. MacDonald
Oil on board, 25.4 x 20.2 cm
The McMichael Canadian Art Collection, Kleinburg (1966.16.38)
Gift of the Founders, Robert and Signe McMichael

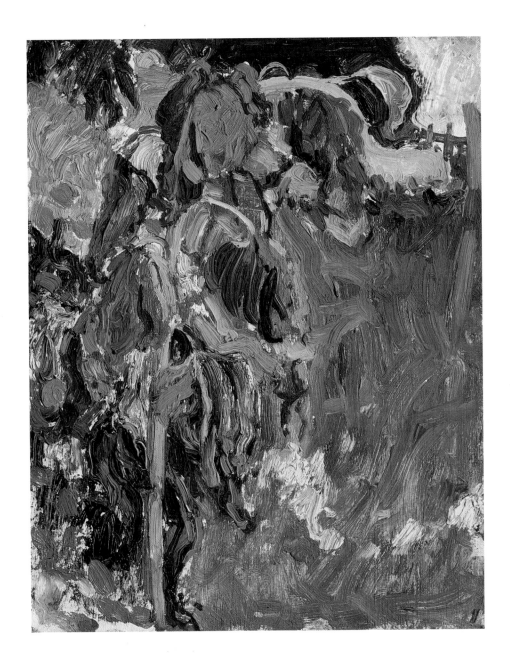

J.E.H. MacDonald's landmark picture *The Tangled Garden* inspired a generation of painters. MacDonald drew his inspiration from a scene that he knew intimately, the garden on the west side of a house in Thornhill, where he had moved in 1912. With its giant sunflower nodding over an untidy garden, *The Tangled Garden* is painted with style, and – so unexpected, given the intimacy of its subject – grandeur. For most Canadians, it depicts the spirit of Canada itself. As a symbol of national consciousness it offers a vivid glimpse of untamed and unruly nature. MacDonald approached the scene, with its dense undergrowth and distinctively shaped flowers, as though painting wilderness. He conveyed the impact of the view with a painterly touch that veered from graceful to bold, his finely tuned sense of colour deftly displaying the reds, purples and pinks jostling among the greens and yellows of his subject. The time is late summer, as we can tell from the blooming sunflowers and asters; from the direction that the sunflowers have turned to follow the sun, we can see that it is morning.

J.E.H. MacDonald

Oil on beaverboard, 121.4 x 152.4 cm

National Gallery of Canada, Ottawa (4291)

Gift of W.M. Southam, F.N. Southam and H.S. Southam, 1937,

in memory of their brother, Richard Southam

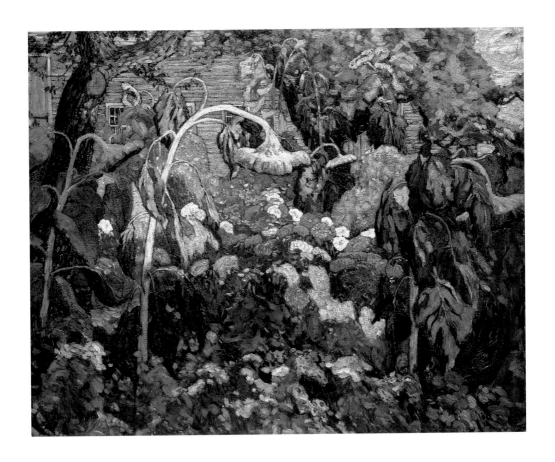

This crowded, close-up study of sunflowers in the full heat of the sun has an extravagant glory that displays a mind excitingly alive to possibilities. On the back of this painting, J.E.H. MacDonald wrote "*Sunflowers/J.E.H. MacDonald/Thornhill 1916.*" The date suggests that this flower study was probably painted the summer after *The Tangled Garden* was completed.

J.E.H. MacDonald
Oil on board, 20.3 x 25.4 cm
Art Gallery of Ontario, Toronto
Gift from the Fund of the T. Eaton Co. Ltd.
for Canadian Works of Art, 1951 (50/14)

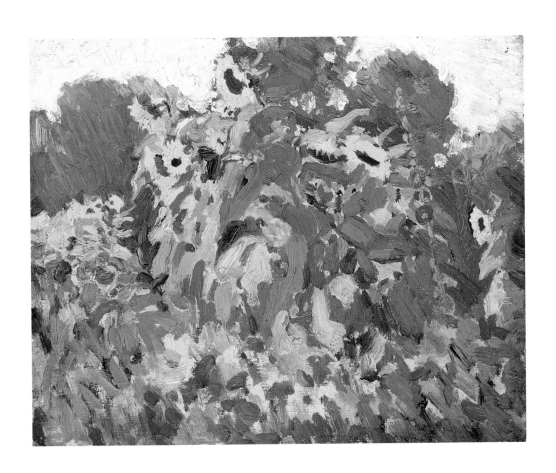

MacDonald sometimes wanted to record his observations as directly as possible without distorting them by finish. Here his work, of sunlit flowers, looks more hastily generalized than uniquely attentive.

In fairness, MacDonald didn't make sketches that are always finished, self-sufficient artworks. They are either exercises or preparatory studies for paintings. However, there is almost always a certain diarist charm to his work.

J.E.H. MacDonald
Oil on board, 25.4 x 20.3 cm
Art Gallery of Ontario, Toronto
Gift from the Fund of the T. Eaton Co. Ltd.
for Canadian Works of Art, 1951 (50/42)

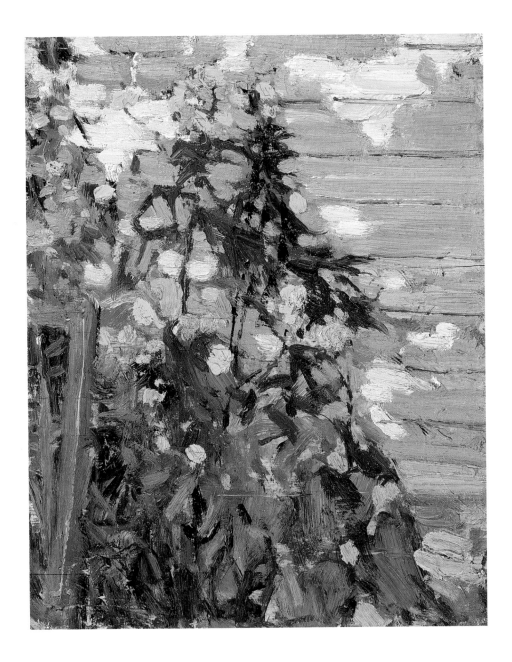

Like *Sunflowers, Thornhill* (page 77), this painting builds to a central image that seemingly towers over the artist. Nature in all its bounty is the message, a reminder that MacDonald always viewed flowers with eyes of sympathy and love.

J.E.H. MacDonald
Oil on board, 20.0 x 25.4 cm
Art Gallery of Ontario, Toronto
Gift from the Fund of the T. Eaton Co. Ltd.
for Canadian Works of Art, 1951 (50/15)

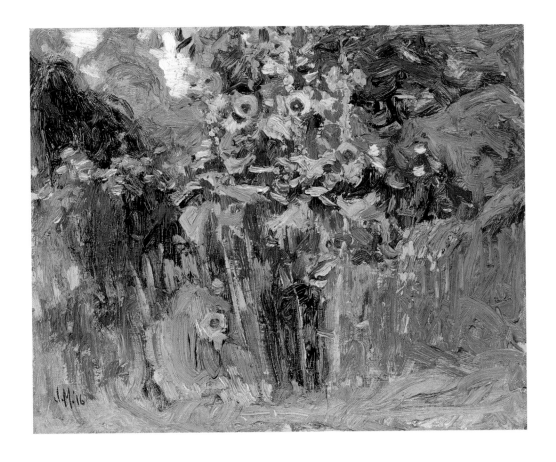

Asters and Apples, 1917

All MacDonald's paintings emphasize images of vitality and growth rendered with flat pattern, heightened local colour and simple but dynamic composition. *Asters and Apples*, which he painted in 1917, tapped into the rich vein he had created. The view, with its gnarled old tree, shows the same section of the garden depicted in *The Tangled Garden*. Apples have fallen on the lawn; the time is late summer or early autumn. Like *The Tangled Garden*, this work is luxuriously disordered and filled with rhythmic repetitions. Yet the result, though fully as decorative, is less an epic than an ode. Still a celebration of nature, *Asters and Apples* is less ambitious than his big-statement painting, more an expression of the private man.

In November 1917 the MacDonald family had to rent their home at Thornhill and move to a small and rickety house at York Mills. The night after moving, while all was still in disorder, MacDonald suffered a complete collapse – probably a stroke – and was unable to get up for many months. A certain aura colours the mood of *Asters and Apples* – the fallen apples among the grasses stir thoughts of the decay of the year, of endings and death. The painting, it would seem, is MacDonald's farewell to his home.

J.E.H. MacDonald
Oil on beaverboard, 53.4 x 66.1 cm
National Gallery of Canada, Ottawa (1427)

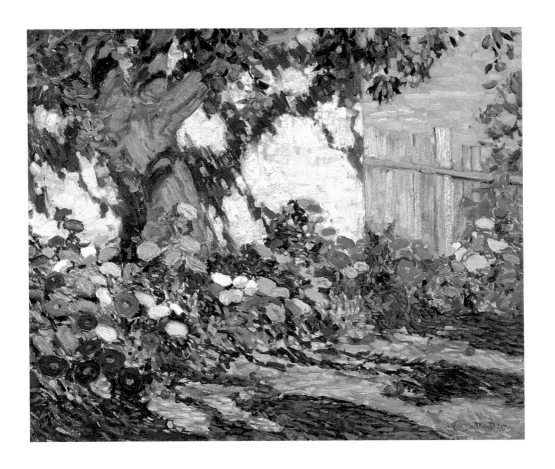

HYACINTHS, 1919

For MacDonald, the subject of flowers offered an incredibly flexible instrument with which to capture colour and light. He regarded flowers both indoors and out with an affectionate eye. This small painting of hyacinths is a reminder of MacDonald's place in the history of floral painting in Canada: he affirmed the vitality of the tradition with élan. Note the way MacDonald often chooses a viewpoint looking up towards the flowers so that they fill the top of the picture. In painting mountains, another favourite subject, he also often focused on the top.

J.E.H. MacDonald
Oil on board, 29.4 x 23.8 cm
Private Collection, Toronto

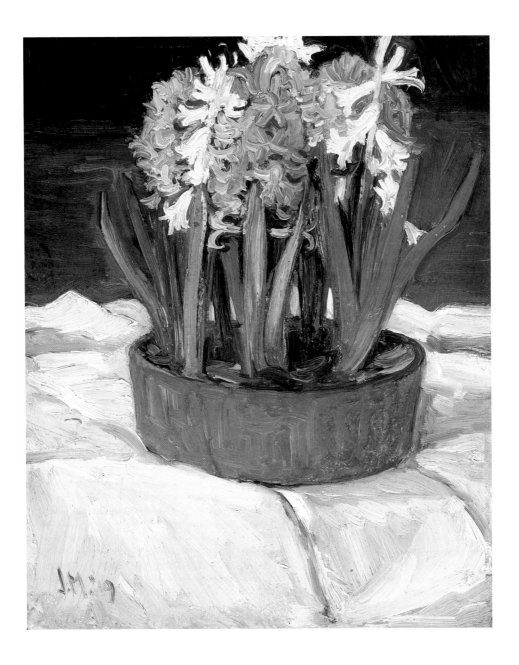

LAKE SIMCOE GARDEN, 1920

MacDonald's image of a child in a garden has an ingenious composition. The expressive fan of flowers behind the child's head seems to suggest something about the figure. The work is a lesson in the elegance of brevity.

J.E.H. MacDonald

Oil on cardboard, 21.5 x 26.7 cm

Art Gallery of Hamilton (62.87.W)

Presented in memory of Suzanne Bowman (1939–1958)

by her parents and friends, 1962

TOM THOMSON, 1877–1917
Died before the Group of Seven was formed

THE LILY POND, 1914

Thomson painted these water lilies in Georgian Bay during a visit to his friend, Dr. James MacCallum, as we know from the material he used — plywood with vertical cracks. In a label on the back, someone, probably MacCallum, wrote *"The Lily Pond/1914."* The water lily has platterlike floating leaves and numerous tapering petals; it grows in quiet waters, but this pond, at least in the distance, looks turbulent and wind-blown.

Tom Thomson
Oil on panel, 21.6 x 26.7 cm
National Gallery of Canada, Ottawa (4691)
Bequest of Dr. James MacCallum, Toronto, 1944

SPRING ICE, CANOE LAKE, 1915

Thomson painted this sketch at one of his favourite painting places on Canoe Lake, Hayhurst Point, across from Mowat Lodge. He gave it as a gift to a friend of his, W. E. Van Clieaf, who worked as a guide in Algonquin Park. The painting features buttercups. Thomson may have made a gift of the work because of the flower. He had painted an image of a buttercup on the bow of Van Clieaf's canoe, which afterwards was known as "The Buttercup."

Tom Thomson
Oil on composite wood-pulp board, 21.2 x 26.4 cm
The Thomson Collection (PC-278)

WILD CHERRY TREES IN BLOSSOM, 1915

Thomson loved painting wild cherry trees with their showy pink or red petals in the spring. There is a tender sensuousness in the brushy application of paint and something humanly touching in the joyously rendered drama.

Tom Thomson
Oil on composite wood-pulp board, 21.0 x 26.0 cm
Alan O. Gibbons, Ottawa

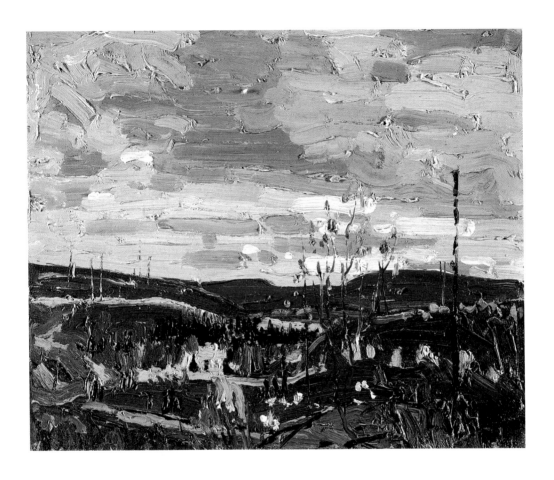

WILD CHERRY TREES IN BLOSSOM, 1915

Thomson was keenly aware of the turbulent quality to spring. Notice the way the wild cherry trees border a swirling pool in this impressively beautiful sketch.

Tom Thomson
Oil on board, 21.6 x 26.7 cm
Art Gallery of Ontario, Toronto
Gift from the Reuben and Kate Leonard Canadian Fund, 1927 (850)

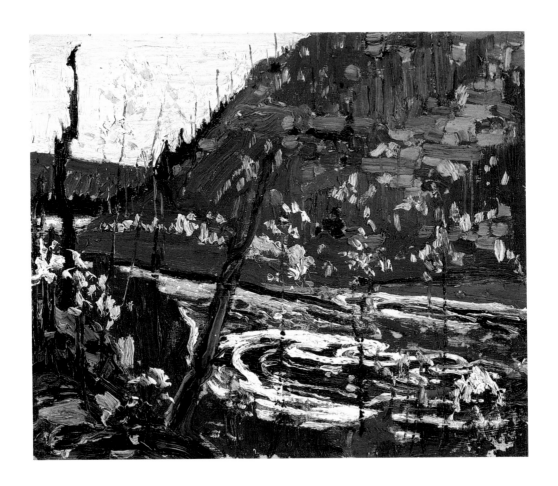

WILD CHERRIES, SPRING, 1915

Here in a section of burned-over landscape in Algonquin Park, Thomson, painting at dawn, has found the prospect of new growth – the wild cherry trees. He used a full brush to paint with apparently casual haste. Nonetheless, the degree of spatial depth and movement in the changing pattern of the sky reveals Thomson skills in painting and design.

On the back of this sketch was written, probably by Dr. MacCallum, "*Wild Cherries/Spring*" and "*1st class.*"

Tom Thomson
Oil on composite wood-pulp board, 21.6 x 26.7 cm
The McMichael Canadian Art Collection, Kleinburg (1966.16.72)
Gift of the Founders, Robert and Signe McMichael

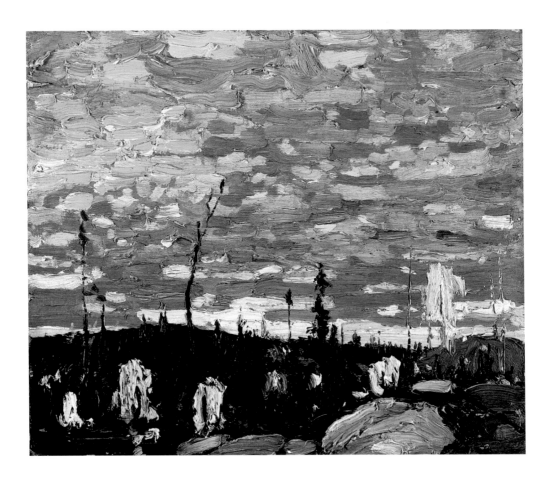

WILDFLOWERS, 1915

Thomson's vivid, seemingly fresh and spontaneous studies of wildflowers burst exultantly against a dark background. Spare yet arresting, each painting has a different colour scheme and grouping. Thomson almost says to the viewer through his art, "I am simply recording essences."

On the back was the inscription "*1st class.*"

Tom Thomson
Oil on composite wood-pulp board, 21.6 x 26.8 cm
The McMichael Canadian Art Collection, Kleinburg (1970.12.2)
Gift of Mr. R.A. Laidlaw, Toronto, 1970

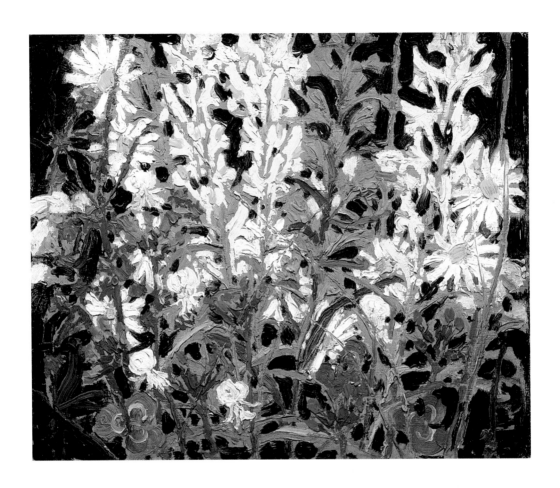

Canadian Wildflowers, 1915

This sketch is one of the few that can be dated to its year of creation: it was shown in Halifax at the Provincial Exhibition in September 1915 as *Canadian Wild Flowers*, where it was for sale at $25.

The work reveals how Thomson responded with instinct and improvisation to flowers, absorbing what he needed but also making do and always in a completely personal way. Everything in the sketch is animated by a visual fragmentation of the surface, which is riveting and yields a painting whose freshness is a joy to behold.

Tom Thomson
Oil on composite wood-pulp board, 21.6 x 26.7 cm
National Gallery of Canada, Ottawa (1532)

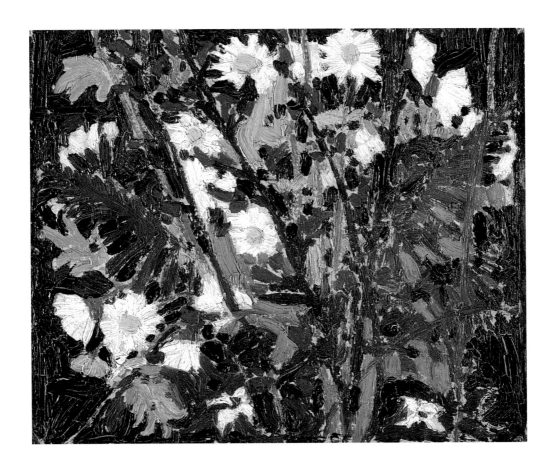

This smouldering sketch shows the viewer that Thomson steadfastly refused to repeat himself. The result has a feeling of revelation. With affectionate warmth and great framing instincts, Thomson makes the everyday world look glorious, even luminous. Note the attention he has paid to the brilliant orange, upward-facing, spotted blossoms of the wood lily, to the tufted, blue-violet vetch and the showy white marguerite daisies, capturing the distinct characteristics of each.

On the back of this sketch, J.E.H. MacDonald wrote *"Not For Sale / J.E.H. Macdonald"*; and on a torn label, the flowers were identified as *"Marguerites – Wood/Lily and Vetch."*

Tom Thomson
Oil on wood, 21.4 x 26.8 cm
Art Gallery of Ontario, Toronto
Gift from the Albert H. Robson Memorial Subscription Fund, 1941 (2563)

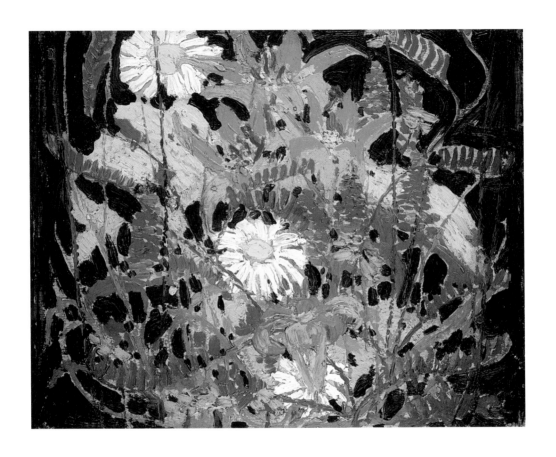

Thomson is at once unassuming and a brilliant designer. Here he has deftly combined the pouch shape of the lady's slipper with other wild-flowers to reflect reality rather than echo it. He orchestrated his evocation of light, atmosphere and flowers into a composition that expresses the vigour of intense engagement.

On the back of the frame was written *"Lady Slipper."*

Tom Thomson
Oil on composite wood-pulp board, 26.8 x 21.7 cm
The Thomson Collection, Toronto (PC-1046)

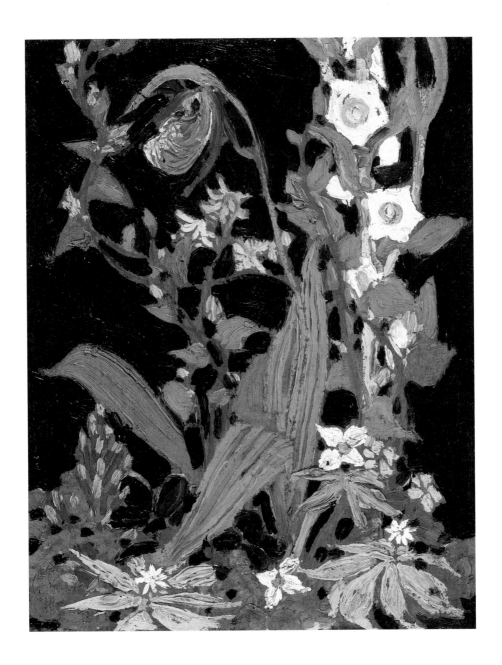

WATER FLOWERS, 1915

In this sketch, Thomson worked more broadly and in flat colour areas, no longer tied to the particularities of the motif, but as always crisply attentive to form.

On the back of this work was written "*Not For Sale*," "*Pickerel Weed / White Waterlilies / Yellow Lilies*" and "*Water Flowers.*"

Tom Thomson

Oil on wood, 21.0 x 26.7 cm

The McMichael Canadian Art Collection, Kleinburg (1976.20)

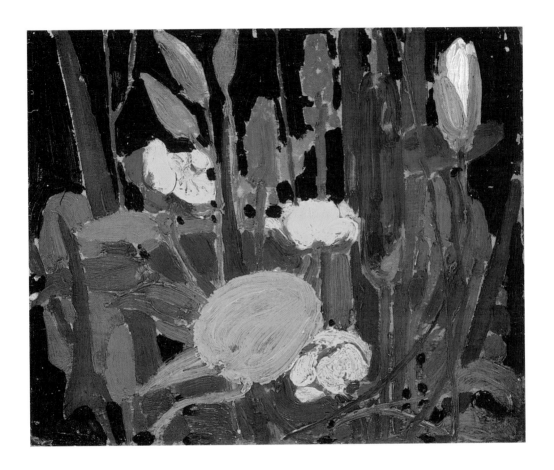

WILD FLOWERS, 1916

For Thomson, painting was a primary formal language, one he made personal and handled with unusual finesse. In this sketch, as in *Water Flowers* (page 107), he handled his brushwork more broadly, but still to impressive effect.

On the back of this work, someone wrote "*design*," and indeed, in this painting of flowers, probably from the Iris family, Thomson created an unconventionally eloquent pattern.

Tom Thomson
Oil on composite wood-pulp board, 21.6 x 26.7 cm
Tom Thomson Memorial Art Gallery, Owen Sound (967.059)
Gift of Mrs. J.G. Henry (Louise Thomson), sister of the artist

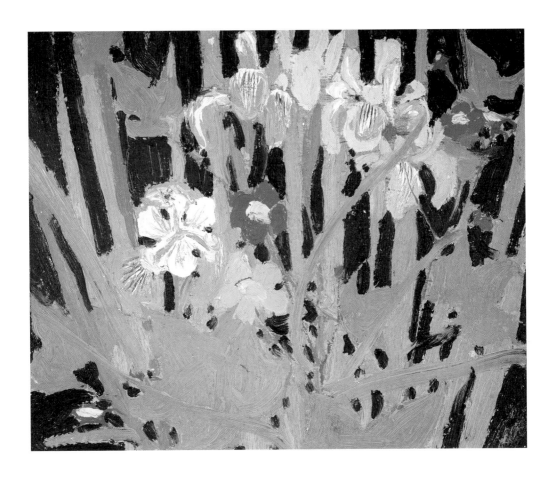

F. H. VARLEY, 1881–1969
Original member of the Group of Seven

FIREWEED, C. 1932–1935

Varley's use of iridescent colour recalls landscape works he painted during this period. The tangled richness of the wild plant with its roundish petals, drooping flower buds and reddish seed pods recalls the labyrinthine richness of *The Tangled Garden* (page 75), but unlike sunflowers, fireweed grows naturally in clearings and fire-desolated areas.

F. H. Varley
Oil on wood panel, 30.5 x 38 cm
Private Collection, Edmonton
©2002 Estate Kathleen G. McKay

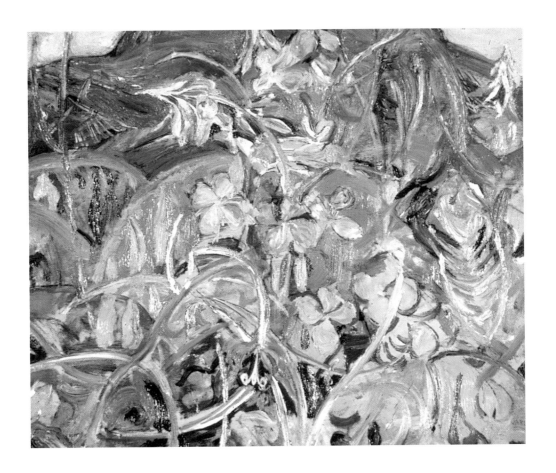

Duval, Paul. *The Tangled Garden*. Toronto: Cerebrus/Prentice-Hall, 1978.

Gerdts, William H. *Down Garden Paths: The Floral Environment in American Art*. Rutherford: Fairleigh Dickinson University Press, 1983.

Hill, Charles C. *Exploring the Collections: Bouquets from a Tangled Garden*. Ottawa: National Gallery of Canada, 1975.

MacDonald, J.E.H. "The Decorative Element in Art," talk given at Toronto's Arts & Letters Club, March 25, 1920, J.E.H. MacDonald Papers, MG30, DIII, vol. 3. Ottawa: National Archives of Canada.

Stacey, Robert. "Harmonizing 'Means and Purpose': The Influence of Morris, Ruskin, and Crane on J.E.H. MacDonald" in *Scarlet Hunters: Pre-Raphaelitism in Canada*, ed. David Latham. Toronto: Archives of Canadian Art and Design, 1998, pages 92–128.

Stacey, Robert, with research by Hunter Bishop. *J.E.H. MacDonald: Designer*. Ottawa: Archives of Canadian Art and Carleton University Press, 1996.

Thom, Ian. *Franklin Carmichael: Prints/Gravures*. Kleinburg, ON: The McMichael Canadian Art Collection and Mrs. Mary Mastin, 1984.

ILLUSTRATION CREDITS

Franklin Carmichael, *Spring* 27
Photograph courtesy of The McMichael Canadian Art Collection, Kleinburg

A.J. Casson, *Summer Flowers; Centre Island* 31
Photograph courtesy of Sotheby's, Toronto

J.E.H. MacDonald, *Asters* 63
Photograph courtesy of Joyner Fine Art Inc., Toronto

J.E.H. MacDonald, *Asters in a Window* 65
Photograph courtesy of Sotheby's, Toronto

J.E.H. MacDonald, *Still Life Study with Roses* 10
Photograph courtesy of Joyner Fine Art Inc., Toronto

Tom Thomson, *Orchids, Algonquin Park* 105
Photograph courtesy of the Art Gallery of Ontario, Toronto

Tom Thomson, *Spring Ice, Canoe Lake* 91
Photograph courtesy of the Art Gallery of Ontario, Toronto

Tom Thomson, *Wild Cherry Trees in Blossom* 93
Photograph courtesy of the National Gallery of Canada, Ottawa

F.H. Varley, *Fireweed* 111
Photograph courtesy of Edmonton Art Gallery

ACKNOWLEDGEMENTS

In preparing this text, I have been greatly helped by curators, registrars, cataloguers and collectors. I would like to thank the following individuals and public and private galleries in particular for their help with information, the location of works and supplying photographs: Christine Braun of the Art Gallery of Hamilton, Beth Shields of the Art Gallery of Nova Scotia, Anna Hudson, Felicia Cukier and Parin Dahya of the Art Gallery of Ontario, Anne Fotheringham, Toronto, Erik Peters at Joyner Fine Art, D.B.G. Fair of the Museum London, Sandy Cooke and Linda Morita of The McMichael Canadian Art Collection in Kleinburg, Alan O. Gibbons of Ottawa, Conrad Graham of the McCord Museum and the McGill University Art Collection, Dr. Naomi Jackson Groves and Anna R. Brennan of Ottawa, Julie Drapeau and Sean Boisvert at the National Gallery of Canada, Ottawa, Jonathan Browns of the Ottawa Art Gallery, Shawna White and Beverly Schaeffer of Sotheby's Toronto, Christopher Varley of Toronto and Mary Jo Hughes and Anneke Shea Harrison and Karen Kisiow of the Winnipeg Art Gallery. In the gallery where I am Director Emerita, The Robert McLaughlin Gallery in Oshawa, Olexander Wlasenko generously offered assistance. I thank them for their help. I would also like to thank Russell Bingham who kindly offered suggestions about the catalogue text.

Joan Murray,
Oshawa

The main text is set in Monotype Fournier. It is a Transitional, or Neo-Classical typeface, originally designed c. 1740 by Pierre Simon Fournier, Paris. It was recut and released in 1926 by Monotype, England. The credits are set in FFMeta, designed 1985–91 by Erik Spiekerman, Berlin.

Separations by Quadratone Graphics, Limited.

Printed by TransContinental Printing.
